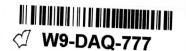

CONTACT SHEET

is published by

LIGHT WORK

a non-profit, artist-run photography organization

316 Waverly Avenue, Syracuse NY 13244

(315) 443-1300 • FAX: (315) 443-9516

http://sumweb.syr.edu/com_dark/lw.html

Jeffrey Hoone
DIRECTOR

Gary Hesse
ASSOCIATE DIRECTOR

Mary Lee Hodgens
ADMINISTRATIVE SPECIALIST

Vernon Burnett
LAB MANAGER

WE THANK

ROBERT AND JOYCE MENSCHEL

THE HORACE W. GOLDSMITH FOUNDATION

THE NEW YORK STATE COUNCIL ON THE ARTS

THE NATIONAL ENDOWMENT FOR THE ARTS

THE INSTITUTE OF MUSEUM AND LIBRARY SERVICES

SYRACUSE UNIVERSITY

AND OUR SUBSCRIBERS

FOR THEIR SUPPORT OF OUR PROGRAMS

CONTACT SHEET is published five times a year and is available from Light Work by subscription for $35. This issue features work from the fifty-sixth exhibition in Light Work's Robert B. Menschel Photography Gallery.

ISSN: 1064-640X • ISBN: 0-935445-08-0

LEWIS WATTS

SOUTH TO WEST OAKLAND

April 5-June 30, 1999
Reception April 16, 6-8 PM

ROBERT B. MENSCHEL
PHOTOGRAPHY GALLERY

Schine Student Center Syracuse University

Gallery hours are 10 am - 10 pm daily

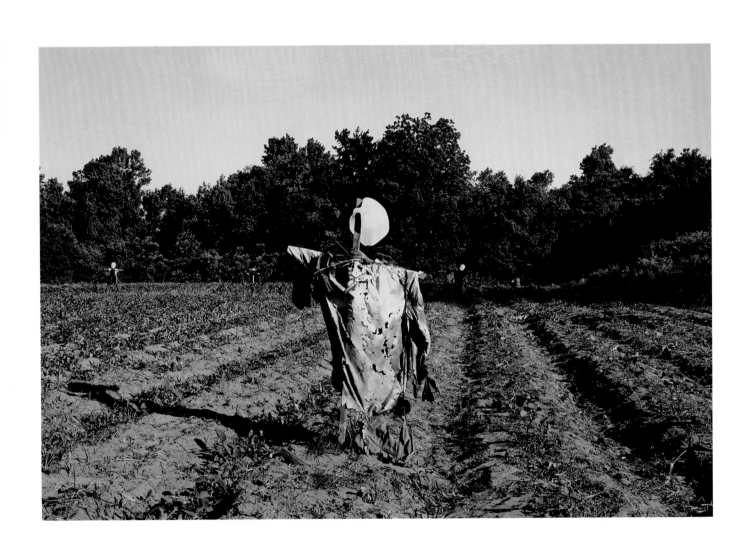

John's Island, South Carolina, 1995

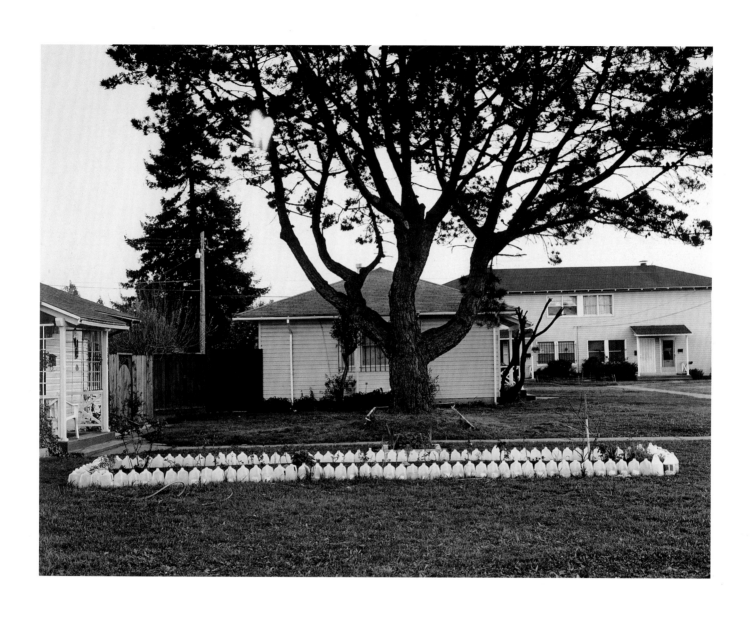

Richmond, California, 1996

The photographs that Lewis Watts made in the southern United States and in West Oakland, California are engaging for what they contain, and for what they are missing. His intent to record and describe the impact and evidence of African Americans in and on the places they inhabit led him to African style graves in South Carolina, aged and faded murals on Beale Street in Memphis, and to a busy barber shop in West Oakland, California. By turning to these small statements of presence Watts explores the theme of invisibility, which the writer Carl Anthony in an earlier issue of *Contact Sheet* described as "a theme presented so powerfully a generation ago in the classic essay, *Nobody Knows My Name*, by James Baldwin."

Throughout the United States there are monumental tributes to Europeans from Mount Rushmore to MacArthur Park, however in a close reading of Watts' photographs the presence of African Americans appear most fully in the improvisation of making do with what is at hand. Again Carl Anthony describes Watts' method for observation when he writes, "The photographer's eye trained to notice elegant architectural detail, classical composition, social fact is drawn to modest situations, events, arrangements, or objects which furnish proof of relationships of caring, reverence, devotion, humility, gratitude, humor, confidence. Not only are these images foreign to highbrow culture, but they invite us to contemplate circumstances, events, deeds, acts, accomplishments which lie beyond the testimony powerfully presented in print." Watts asks us to acknowledge that testimony through his observation of improvisation where meaning is built from the most basic materials, and where memory resides in rituals passed from place to place.

There is a timeless quality to many of Lewis Watts' photographs as they seem caught somewhere in a cycle of history. Some look like he was peering over the shoulder or around the corner from Walker Evans, others recall Robert Frank, Dorothea Lange, and Roy DeCarava, and others perhaps even Clarence John Laughlin. But within the tradition of documentary photography Watts has decided to concentrate on the details that define the meaning of journey and the signposts that survive after the parade has gone by. In Memphis Watts records an aged and peeling mural that might have depicted Billie Holiday located somewhere in the vicinity of the long lines forming at the gates of Graceland. In Edisto Island, South Carolina Watts found African style grave markers not very far removed from the gated community of Hilton Head where each morning hundreds of black day workers enter the city wearing identity badges. In West Oakland, Watts finds the memory of Huey Newton scrawled in graffiti along a tattered strip of Martin Luther King Way.

By drawing us into the details of his observations Watts often presents small mysteries that force us to look for a larger meaning outside of each individual image. Those clues can lead us from Beale Street to Graceland, from Edisto Island to Hilton Head, and from West Oakland to West Africa and back again. There are many journeys contained in Lewis Watts' photographs and if we pay close attention it seems that each image can move us through a continuous cycle of memory, ritual, and renewal.

Jeffrey Hoone
Director
Light Work

Joe, Garvey Park, West Oakland, 1993

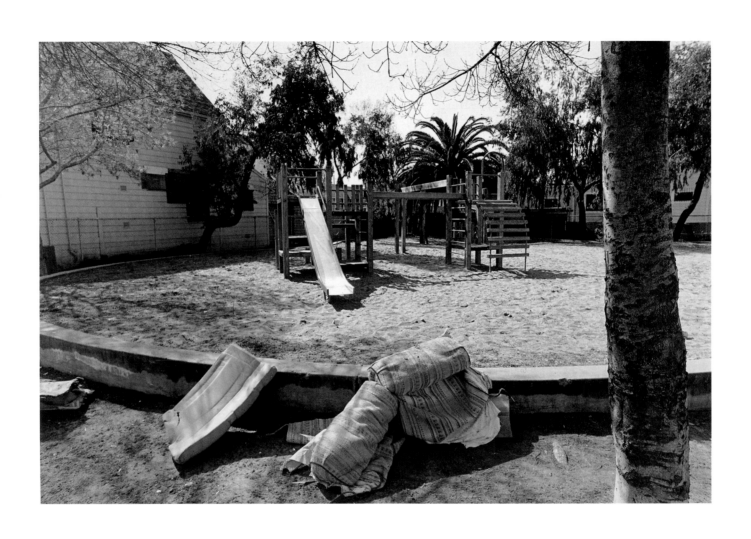

25th Street Park, West Oakland, 1993

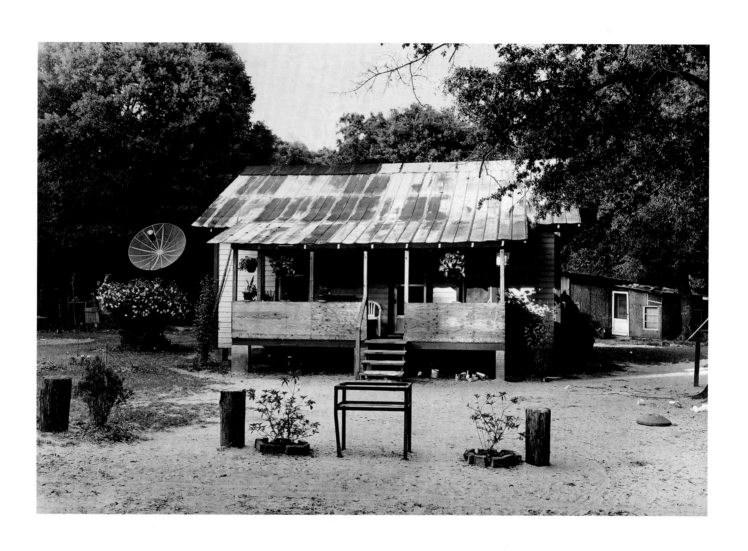

Quincy, Florida, 1993

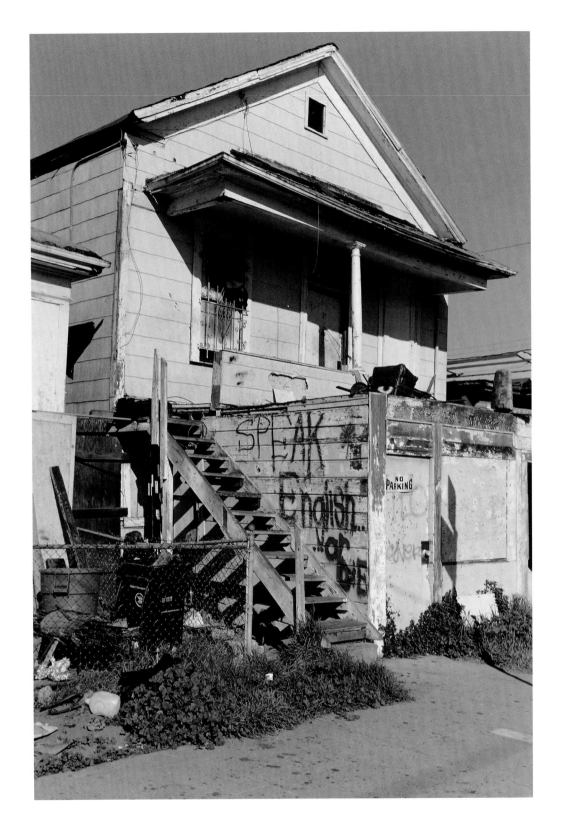

West Oakland, 1997

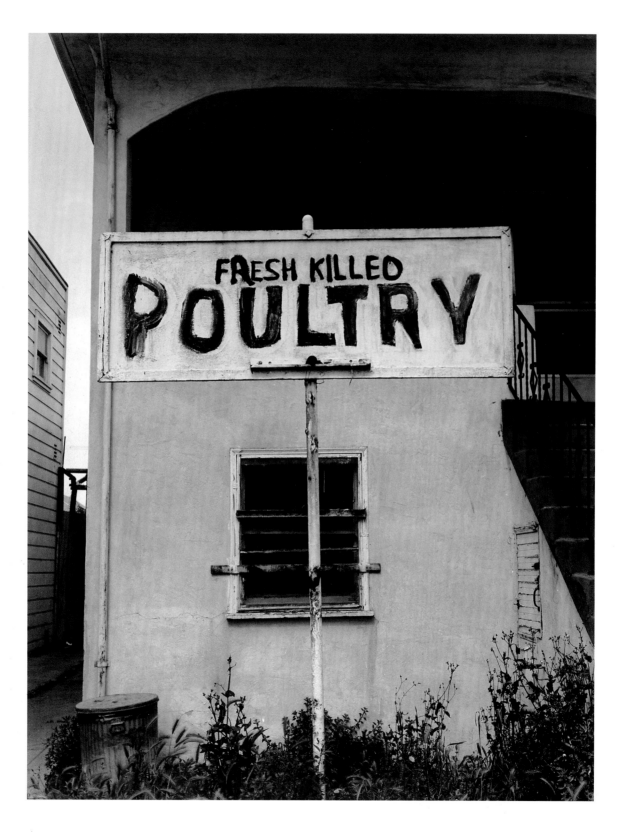

West Oakland, 1993

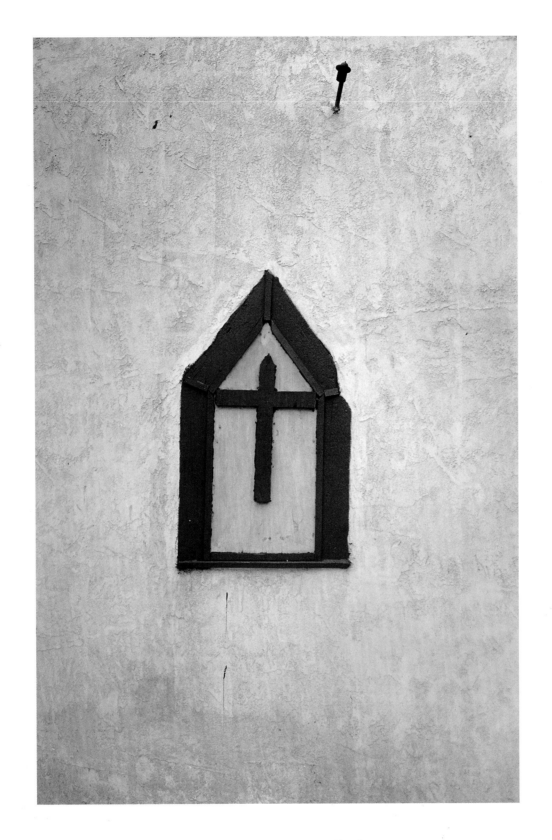

Trinity Holiness Church, West Oakland, 1993

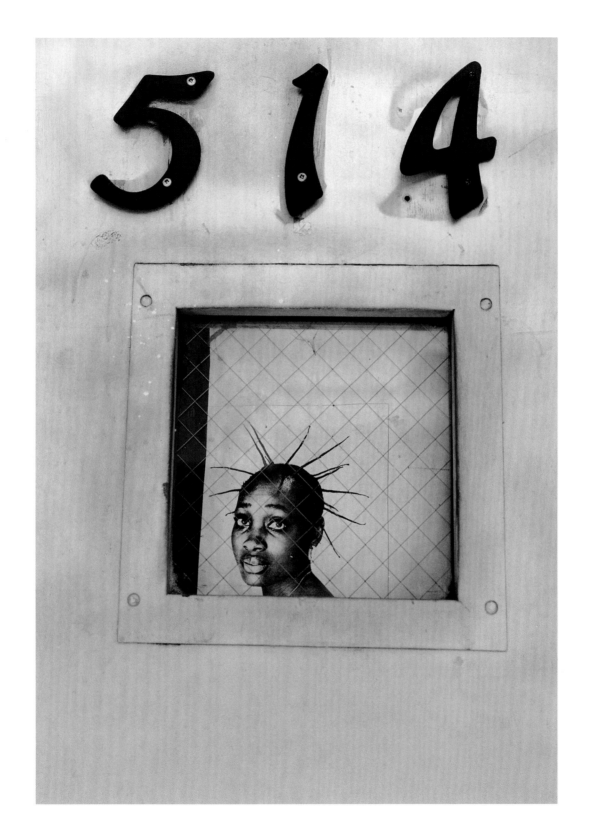

Old Oakland, 1997

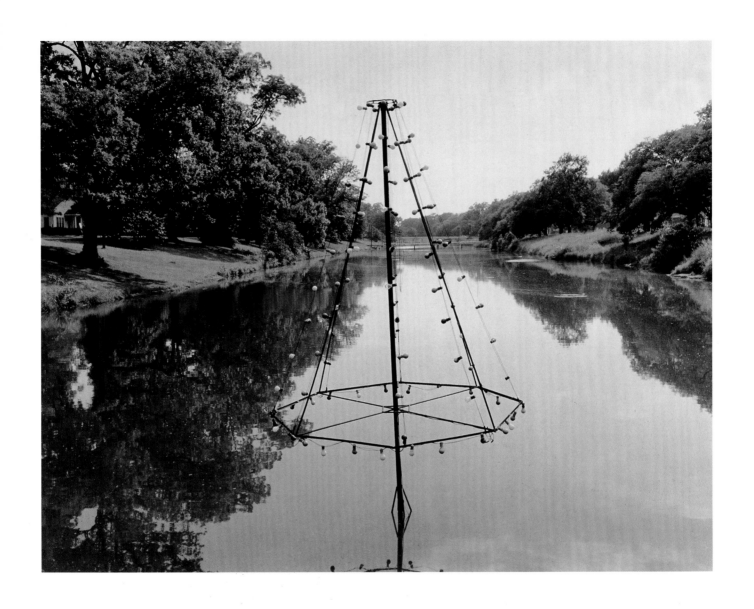

Louisiana, 1994

Cancer Alley, Louisiana, 1994

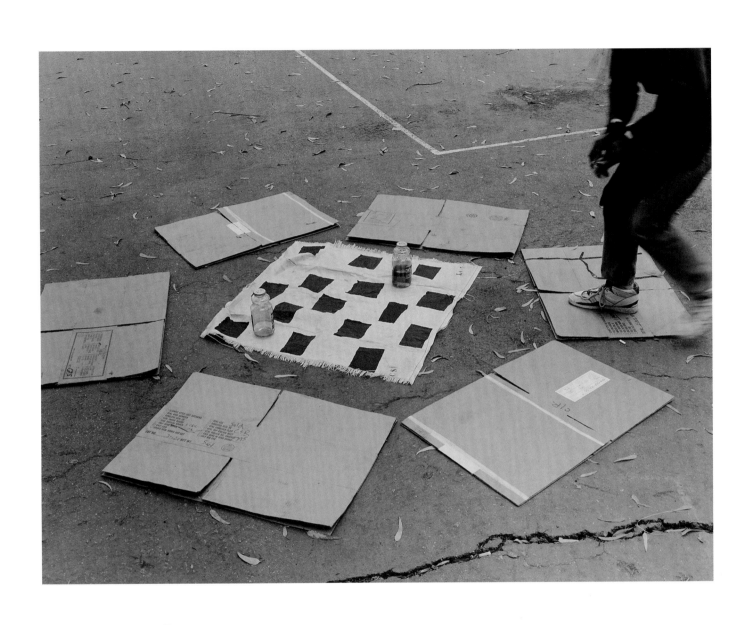

Joe's Installation, West Oakland, 1993

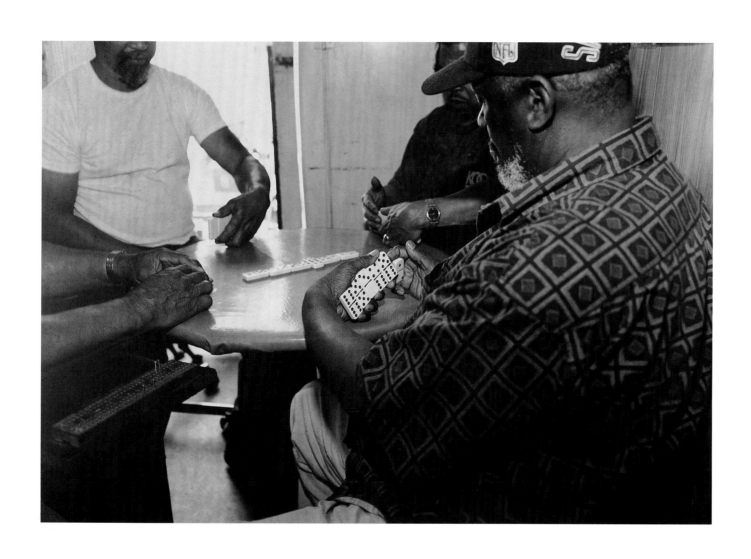

New California Barbershop, West Oakland, 1997

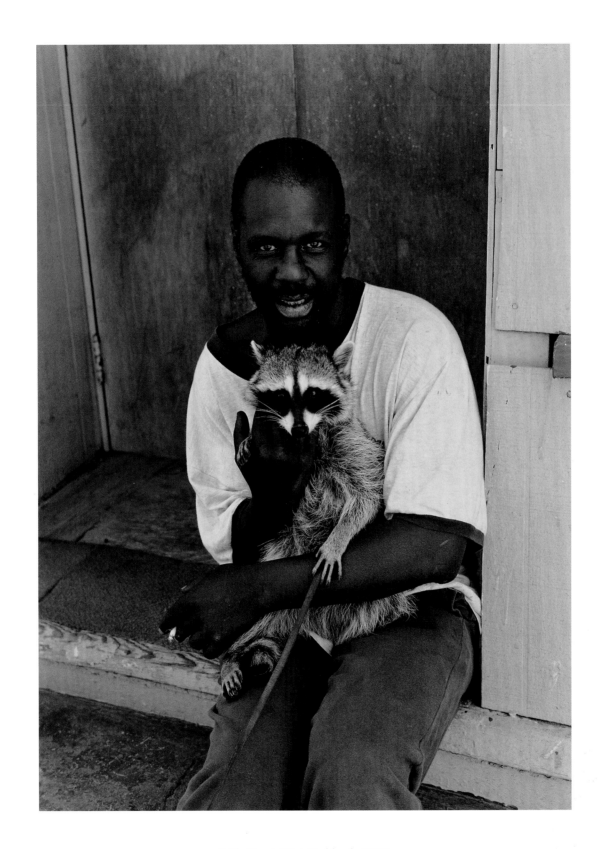

34th Street, West Oakland, 1997

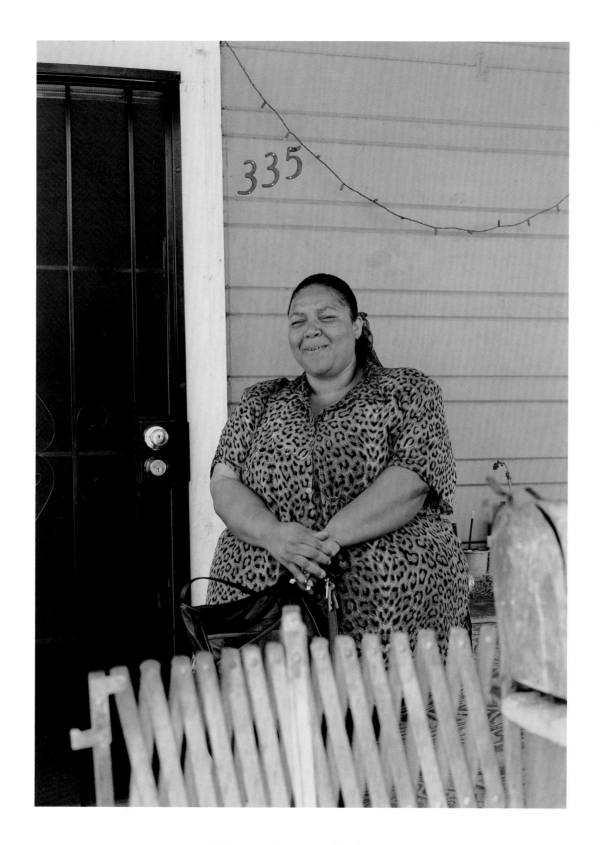

Sobrante Park, East Oakland, 1997

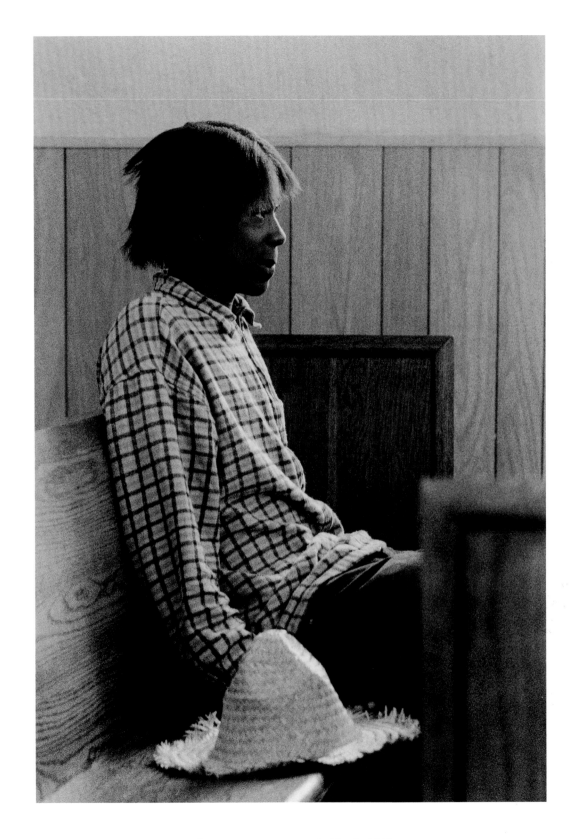

The Upper Room, West Oakland, 1997

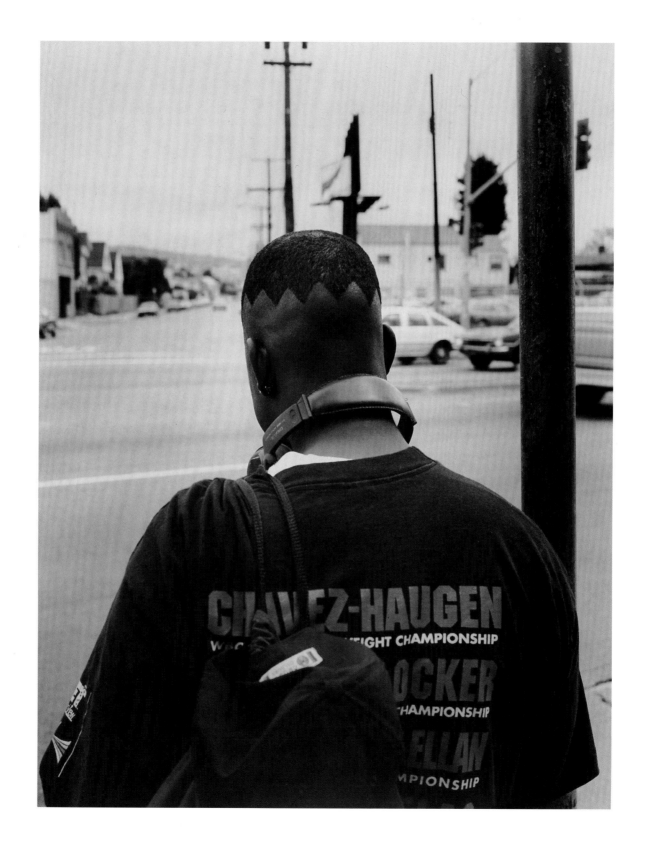

San Pablo Avenue, West Oakland, 1993

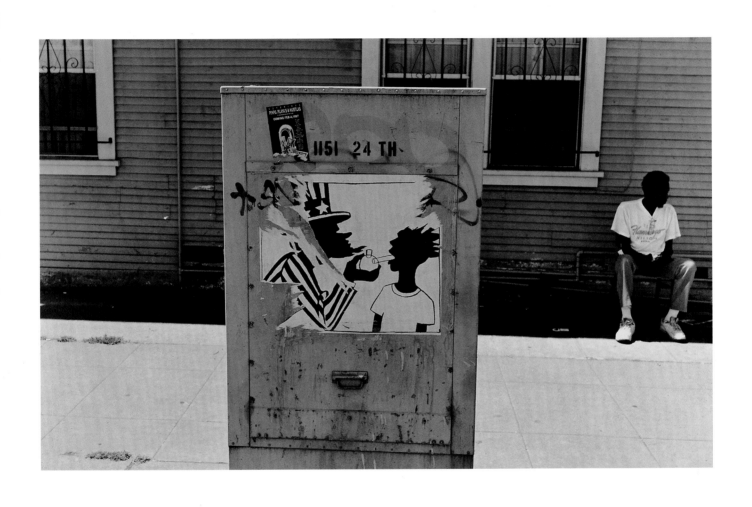

24th Street, West Oakland, 1997

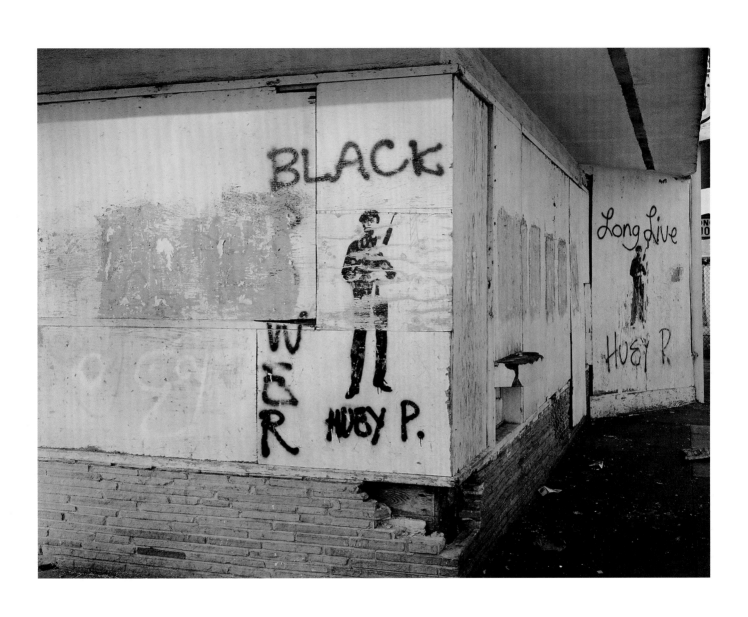

Martin Luther King Way, West Oakland, 1993

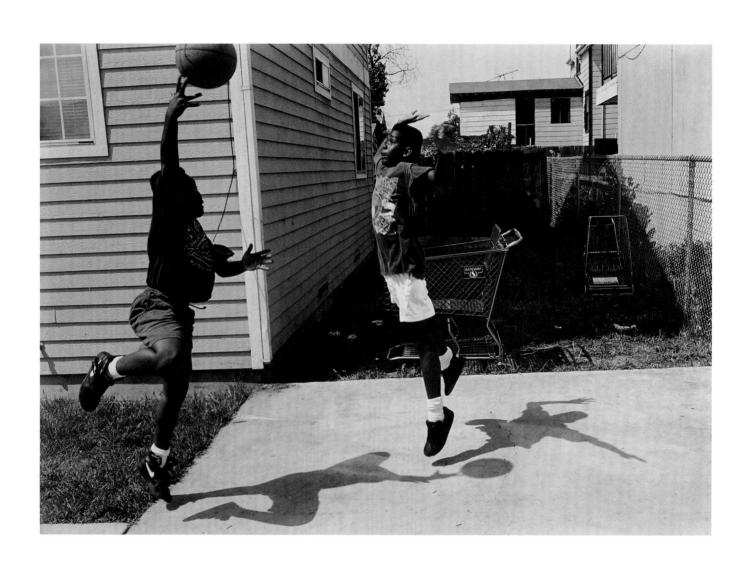

Martin Luther King Way, West Oakland, 1993

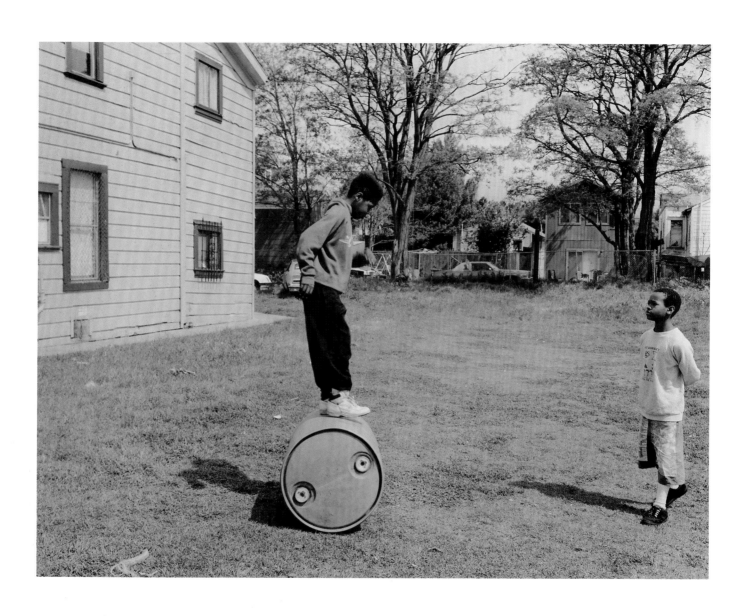

West Oakland, 1993

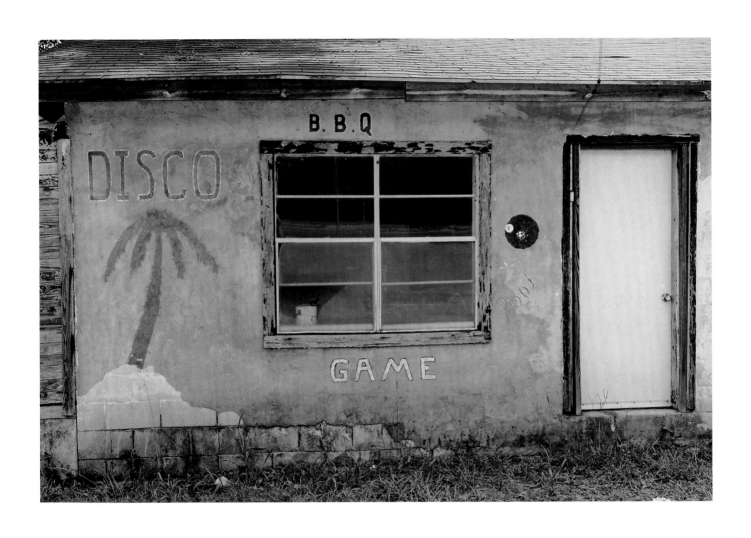

Havana, Florida, 1996

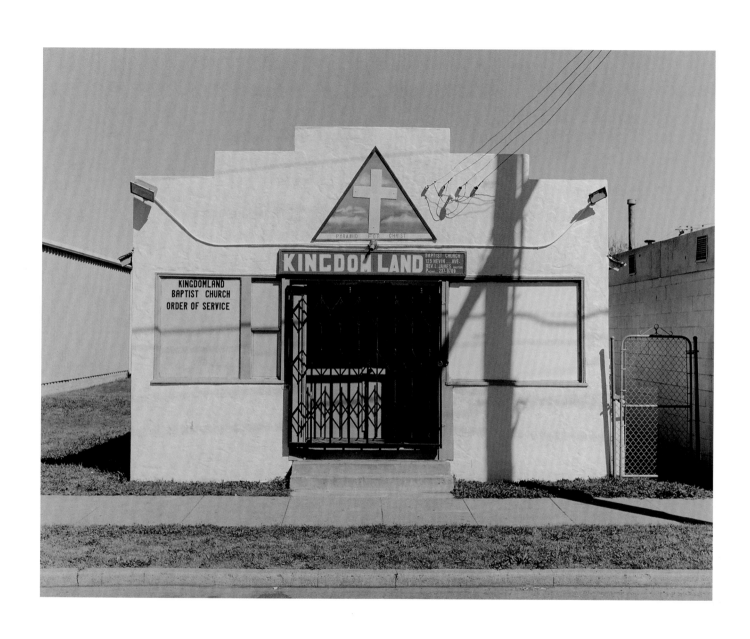

Richmond, California, 1995

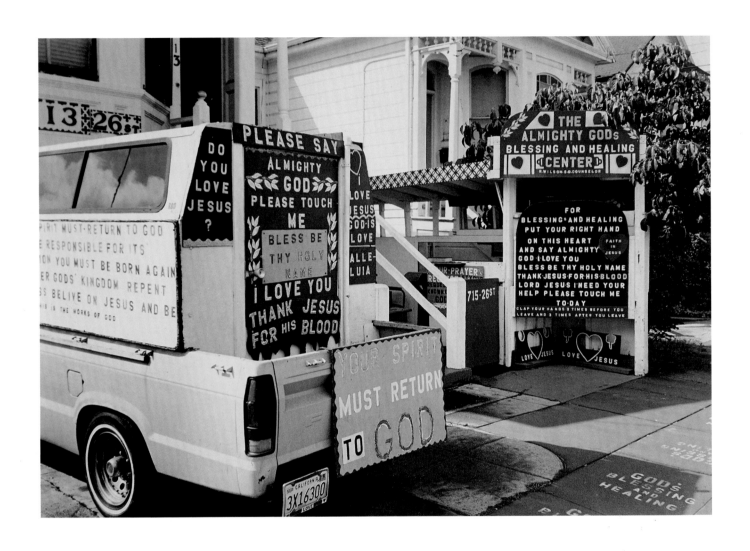

West Oakland, 1993

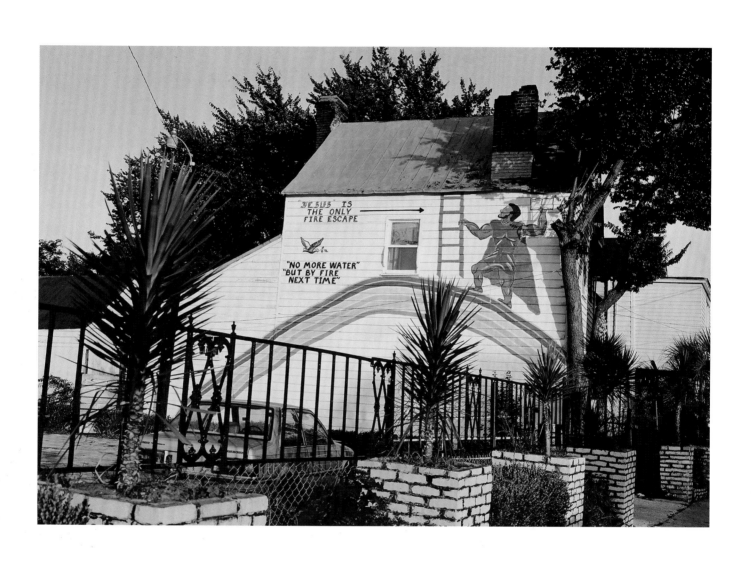

Charleston, South Carolina, 1995

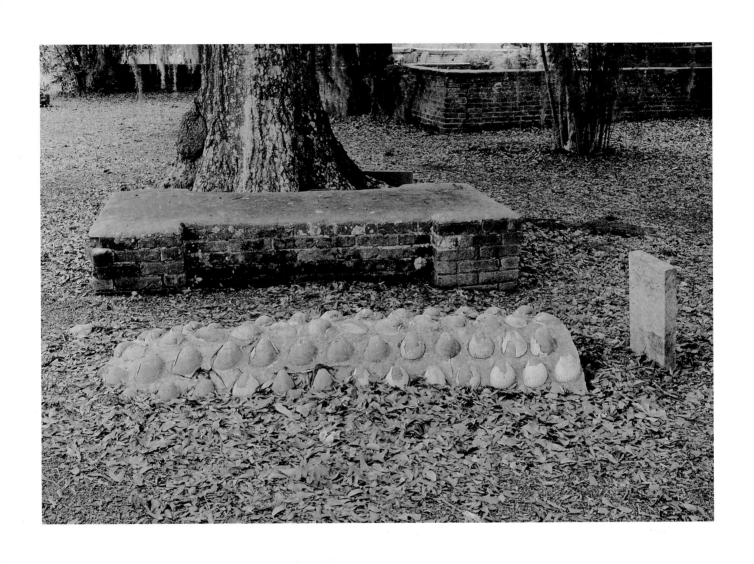

Thomasville, Georgia, 1996

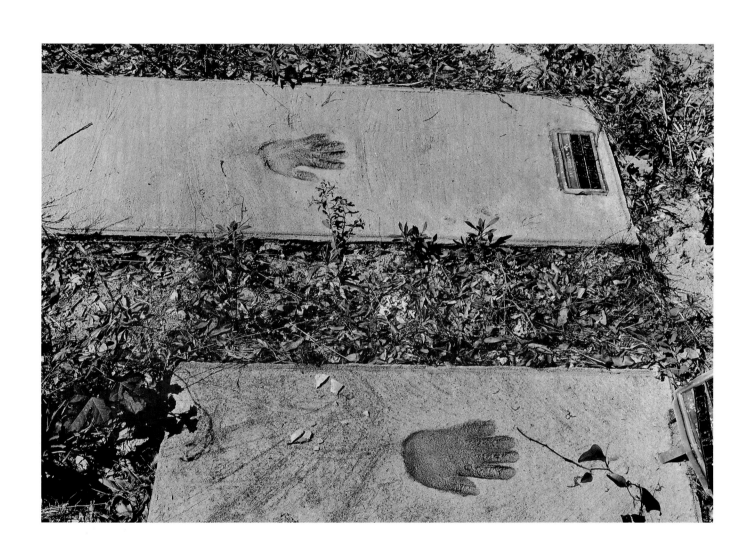

Edisto Island, South Carolina, 1995

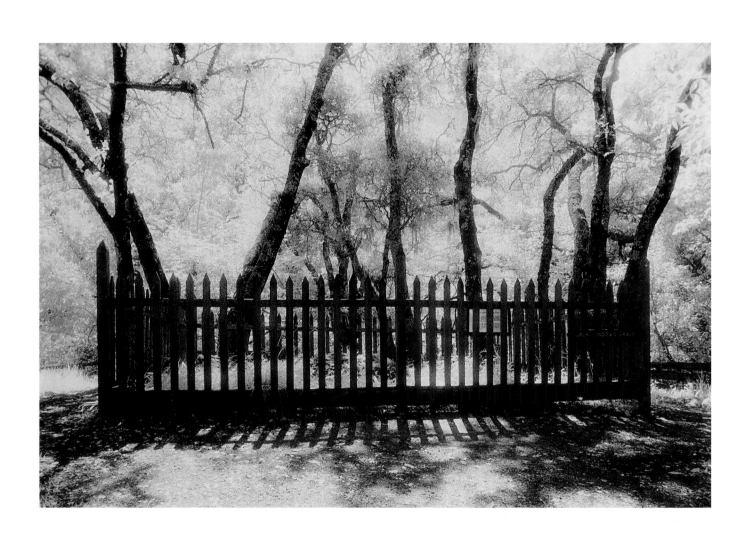

Jack London's Grave, Glen Ellen, California, 1990

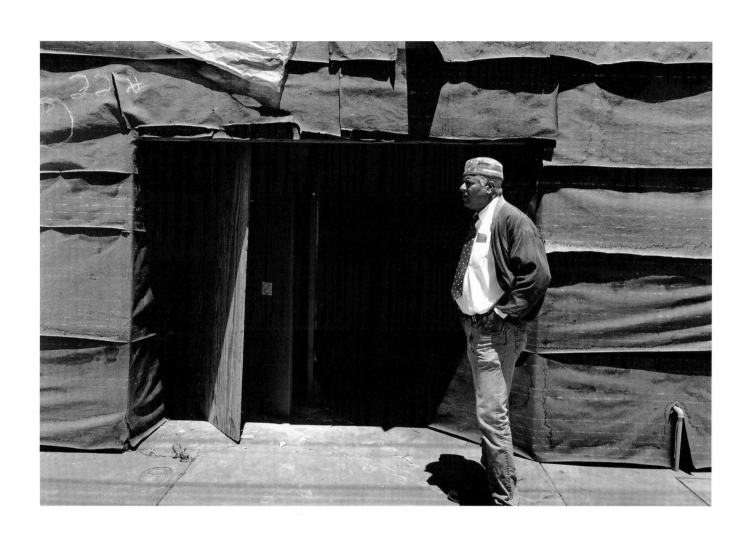

Reverend Carlisle, Oakland Community Church, West Oakland, 1997

Lewis Watts has been a Lecturer in Photography and Visual Studies in the College of Environmental Design at the University of California, Berkeley since 1978. Watts has had a long association with UC Berkeley where he received both a BA in Political Science in 1969, and an MA in Photography and Design in 1973.

Since 1974 his work has been exhibited at numerous institutions including; The Studio Museum in Harlem, San Francisco State University, The Baltimore Museum, Florida A & M, and most recently in a solo exhibition titled *Urban Footprints* at the Oakland Museum curated by Drew Heath Johnson.

Watts has had his work included in numerous publications including; *The Black Photographers Annual*, Vol. 2, 1974 and Vol. 3, 1976, *Smithsonian Magazine*, *The New York Times*, and *Progressive Architecture*. His work is also in several permanent collections including; The National African Museum Project at the Smithsonian Institution, The Studio Museum in Harlem, the Oakland Museum, and The California Historical Society.

Lewis Watts lives in San Anselmo, California and he participated in Light Work's Artist-in-Residence program in 1996.

All photographs are 16 x 20"
silver gelatin prints.